AT HOME WITH THE
IMPRESSIONISTS

Masterpieces of French Still-Life Painting

by Jeffrey E. Thompson

The Phillips Collection / UNIVERSE

First published in the United States of
America in 2001
by UNIVERSE PUBLISHING
A Division of Rizzoli International
Publications, Inc.
300 Park Avenue South
New York, NY 10010

Library of Congress Control Number:
2001089980

ISBN: 0-7893-0622-0

2001 2002 2003 2004 2005 2006 /
10 9 8 7 6 5 4 3 2 1

Designed by Amelia Costigan

Edited by Johanna Halford-MacLeod,
Director of Publications, The Phillips
Collection, and Christopher Steighner,
Editor, Universe Publishing

Printed in England

Photo Credits:
© Corbis: pp. 6–7, Farrell Grehan;
p. 13, Owen Franken; p. 57, Hulton-
Deutsch Collection. © Giraudon, Musée
Marmottan-Monet, Paris: pp. 26–27;
p. 30; p. 31. © AKG London: p. 56.
© Roger-Viollet: p. 4, p. 12.

Front cover:
Claude Monet, *The Tea Set* (detail), 1872
Oil on canvas, 53 x 72.5 cm
Private Collection
Courtesy of Dallas Museum of Art

Endpapers and case:
Paul Cézanne, *Pears and Knife* (detail),
1877–1878
Oil on canvas, 20.5 x 31 cm
Private Collection

Page 8:
Edouard Manet, *Three Plums* (detail), 1880
Pen, brown ink, and watercolor on paper,
14 x 21 cm
Collection of Mrs. Alex Lewyt
Courtesy of American Federation of Arts

Page 28:
Edouard Manet, detail from
illustrated letter (snail on leaf), 1880
Watercolor on paper, 14.6 x 10.8 cm
Collection of Mrs. Alex Lewyt
Courtesy of American Federation of Arts

Page 54:
Edouard Manet, detail from
illustrated letter to Marthe Hoschedé
(chestnut), 1880
Pen, brown ink, and watercolor on paper,
24.5 x 20 cm
Collection of Mrs. Alex Lewyt
Courtesy of American Federation of Arts

Back cover:
Edouard Manet, *Branch of White Peonies
with Pruning Shears* (detail), 1864
Oil on canvas, 31 x 46.5 cm
Musée d'Orsay, Paris, Bequest
of Count Isaac de Camondo
© Art Resource, Photograph by
Erich Lessing

Back cover quotation:
Edouard Manet. Quoted in George
Mauner and Henri Loyrette, *Manet: The
Still-Life Paintings* (New York: Abrams,
2000), 12.

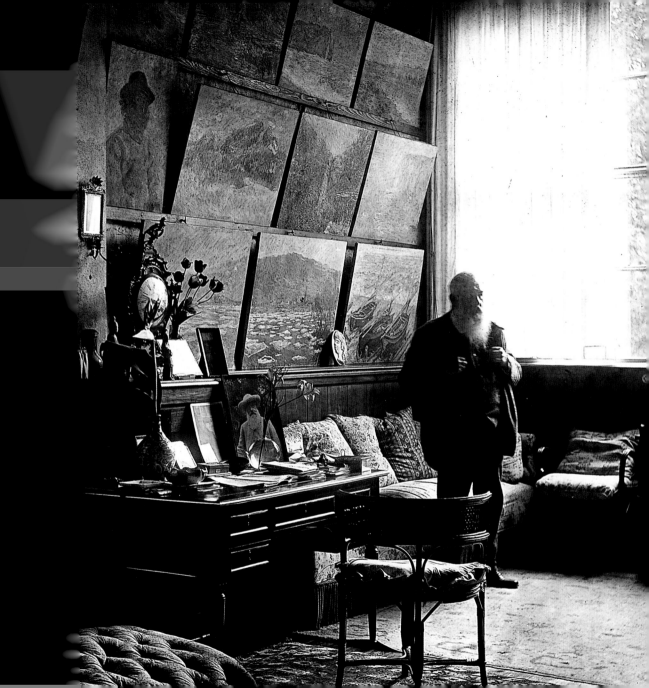

Introduction

Impressionist still lifes convey the atmosphere of the home. They reveal a different side of a movement widely known for its depictions of outdoor leisure activities in the rapidly modernizing Paris of the later nineteenth century. In inclement weather, still life was an alternative to outdoor work. It was a resort for artists whose energy was diminished by ill health or an exhausting campaign of work. Still life, called "dead nature" in French (*nature morte*), typically records painterly arrangements of objects in the studio and alludes to a private, domestic world, indoors.

Excerpts of the middle-class domestic environment, these generally smaller-scale works capture the tones and textures of the home's different spaces: the polished wood of parlor furniture, the hefty folds of damask tablecloths, and the substantial crust on a loaf of bread. They present the many meanings of home and indicate the financial and emotional investment in its different rooms. In the parlor and the dining room, customs and rituals are practiced — from being "at home," meaning available to visitors, to celebrating life's milestones, sharing the fellowship of a meal. The nineteenth-century kitchen is the site of important transformations, where raw materials became elaborate meals in that era of fine dining. The garden is also embraced as an important adjunct to the home, and the painters themselves were often avid gardeners.

On another level, "home" exists as a collection of memories. The still-life paintings can be deeply felt evocations of a house, complete with signs of its occupants: a peach lifted off the top of a carefully arranged pyramid of fruit; the garden shears next to a recently cut peony; a cherished faïence soup tureen handed down through several generations. The paintings serve memory in another way. Because of their relatively small size, still lifes were often deemed suitable as personal gifts and became, once inscribed, fond mementos of time spent together.

In their fictive interiors, the painters bring to the objects they assemble such intense visual scrutiny that the paintings take on an immediacy and energy belied by their brief mundane titles. Through their dazzling paint technique and apt compositions, the painters take us around the home and garden, directing our vision in new angles and showing us intriguing corners of their daily life. ⚜

Monet in his sitting room at Giverny, 1920

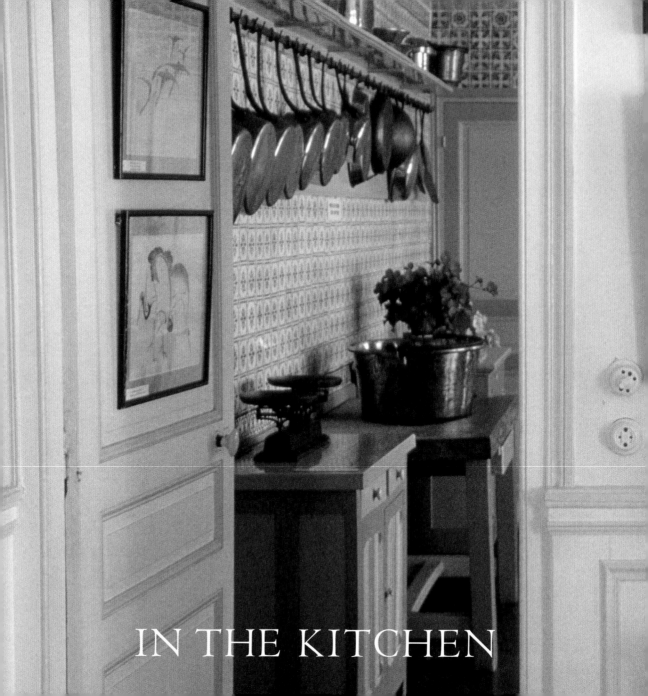

IN THE KITCHEN

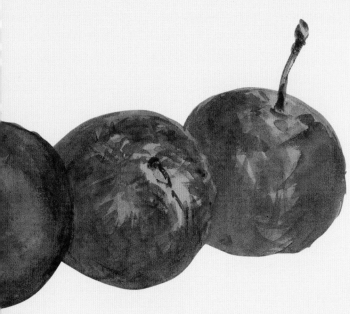

In the world of the kitchen the Impressionist painters found a natural bounty of textures and

colors, an ease in setting up props, and endless opportunities for honing technical skills. Kitchen still-life themes could be widely varied: produce of the sea or the farm; the sweet or the savory dish; meager or luxurious fare. Each motif had to fit into the painter's current preoccupation. Vincent van Gogh found in a grouping of apples the chance to put side by side vibrant, separate hues (see page 23). Claude Monet captured the light reflected off the surface of glazed flaky pastry set out to cool on racks of woven reeds (see page 24). Pierre-Auguste Renoir defined the volume of onions using distinctively angled brush strokes (see page 23). Edouard Manet used strokes of dense paint to depict the shine of fish scales (see page 14).

Kitchen still-life painting of the Impressionist era seems to present daily life at its most basic. Although the food shown sitting on tables or counters, usually trapped in a small space enclosed by a wall, was almost certainly arranged in the artists' studios, the resulting images reflected some of

Edouard Manet, *Three Plums* (detail), 1880
PRECEDING: Kitchen doorway in Claude Monet's house at Giverny, c. 1867

the cramped realities of the contemporary kitchen. Rudimentary and often unhygienic, the typical Parisian kitchen was located as far as possible from living areas. Whatever the charms of French cuisine, the smell of food was welcome only at mealtimes. A fireplace or ovens fueled by wood, charcoal, or gas supplied the heat for cooking. It was in these distant corners of the house that housekeepers and cooks assembled the raw materials from markets or shops and transformed them into sustenance for the family.

In nineteenth-century France, when techniques of food preservation were only beginning to be developed, the seasons ruled over the availability of most items. Game birds had their seasons, tied to the calendar of the hunt, though industrious housekeepers preserved portions of game or fowl in rendered fat (see page 20). Hams, like the one painted by Paul Gauguin could be cured or salted (see page 21). Ripe fruits preserved in brandy according to long custom as in Monet's *Jar of Peaches* were a delight to be rationed, a taste of summer in the dark months of winter (see page 25). Otherwise, the season held sway, and perishable fruits and vegetables were best consumed at their prime.

At the beginning of the century, most food was produced on a small scale and was usually tied to a region where soil, climate, and traditions of cultivation yielded superior produce. As Paris and its increasingly epicurean middle class grew, the capital launched a frenzied commerce in the finest food. Improved methods of transportation sped up the arrival of regional ingredients in quantity. Emile Zola's novel *The Masterpiece* (1886) opens with a flash of lightning that illuminates barges moored four deep along the river and laden with golden piles of apples. With reliable supplies of food and well-heeled consumers, Parisian taste and style triumphed and came to epitomize gastronomic excellence. At the same time, the new railroads made the provinces and the discovery of regional cooking accessible to city dwellers.

For cooks and painters of kitchen still life alike, what sets the creative juices running is the sight of uncooked ingredients. It is their raw, visual qualities that inspire thoughts of recipes, and both painters and cooks use the term, for color and culinary preparations respectively. Not surprisingly,

more often than not, the fish, lemon, or vegetable we see in Impressionist still-life painting, as in most still life, awaits the first stage of preparation. Painters and writers encountered the changing world of food in the markets, especially in Paris's central markets after their renovation by Baron Haussmann as part of his celebrated rebuilding of the city. Zola set his novel *The Belly of Paris* (1873) in the central markets, and Claude Lantier, the modern painter in Zola's *The Masterpiece*, uses the markets as the setting for one of his paintings in his planned series of monumental scenes of modern Parisian life. The copious bounty of the market stalls, arrayed in categories, would have appealed as much to the roving visual curiosity of many artists, as it would have done to the cook or housekeeper out shopping for the household's provisions.

In the realm of vegetables, asparagus was in great demand. Its appearance marked the coming of spring — at some point between March and April — and its laborious cultivation often drove prices high. Farmers would bank up earth around the stalks, keeping them in the dark as they grew, in order to produce the large, succulent, white stalks and tightly closed tips that were so prized in Paris at the time. After a brief appearance, the vegetable was gone by late June. In Manet's famous still life, *A Bunch of Asparagus,* the squarish bunch vibrates at the tips as delicate layers of color accumulate there (see page 19). Up the sides of the bunch, the white stalks seem to bask in the verdant green of the grassy nest. The painting is a compelling year-round promise of spring.

A fishmonger would display his stock in ranks, a veritable marine encyclopedia: the flat fish — sole, flounder, turbot; the red fish — snapper, mullet, scorpion-fish; and the cod. The differing weights and shapes of the fish and the various hues floating beneath the glistening scales and fins would have challenged a painter's organizing eye. Oysters were a product of the sea cherished by eaters and artists alike (see page 14). One estimate had mid-century Parisians eating an average of six dozen oysters per person per year. Not surprisingly, both natural and cultivated oyster beds were periodically threatened with extinction through over-harvesting. Oysters were usually served raw with the acid hint of lemon juice or a vinegar sauce. Their shells were compact fields of observation for the painter: the exteriors, matte and dark as the sea; the interiors, smooth and brightly

Camille Pissarro, *Still Life* (detail), 1867

reflective. A Parisian eating oysters traveled through the senses. Named for the places where they were harvested, oysters evoked points along the Channel coast: Cancale, Etretat, Dieppe, Ostend.

Although accounts survive of rowdy impromptu meals in the studios of the painters and of meals eaten out, it is difficult to reconstruct what dishes were prepared frequently in the kitchens of the Impressionists. Zola's fictional painter, Claude Lantier, prepares a rudimentary meal of vermicelli redolent of his upbringing in the south of France. Julie Manet reported that Degas was rumored always to serve the same dinner, "*rillettes de pays,* chicken, salad, and preserves, all prepared by Zoë [his housekeeper]." However, it is likely that dishes prepared in certain traditional styles made an appearance in the households of the Impressionists. For example, dishes prepared *à la boulangère,* "in the manner of the baker's wife" (garnished with casseroled potatoes and onions), or *à la charcutière,* "in the manner of the butcher's wife" (in a mustard-cream sauce with thinly sliced tart sour pickles or capers). The names of such dishes speak to little domestic economies in both shopping and cooking. The baker would allow clients in the neighborhood to cook their casseroles in his ovens, using the heat left over when the bread baking was done for the day. The butcher, or supplier of prepared meats, would recommend a quick sauce to go along with dishes rich in pork. Some meals were prepared using ready-cooked dishes, bought commercially at a *traiteur* and taken home. These, along with bread, could round out a meal prepared over a small burner. Specific authentic recipes used by the Impressionists are harder to find. Most recipes employed in homes did not come from books but came into a family's usage in the old-fashioned way: handed-down, swapped, or worked up in emulation of a dish enjoyed at a cherished restaurant.

Edgar Degas and his housekeeper Zoë Clozier, c. 1900

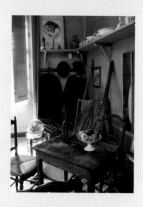

Larger, more prosperous households were likelier to preserve recipes. From Monet's kitchen at Giverny many details survive. Monet and his second wife, Alice Hoschedé, were well off, and the kitchen at Giverny, like Zola's in Médan, is an elaborately tiled room, with all the proper work spaces and rows of cooking pots — separated by function and racked in graduated order by size. In Monet's time, it was run by collective effort, including the women of the family and household help. Recipes at Giverny bore the names of friends (Cézanne's *brandade de morue* or purée of salt cod), or of their housekeepers, or of some of Paris's finest chefs or their restaurants (Foyot, Marguery, Café de Paris). These recipes reflect a well-to-do household, able to travel and seek out special meals.

Pierre-Auguste Renoir's household, perhaps less structured than Monet's at Giverny, also served large numbers of dinner guests. Its food was overseen by Renoir's wife, Aline Charigot, who learned the typical cuisine of the Midi during the family's yearly stays at Cagnes-sur-Mer in the south of France. Aline's bouillabaisse was legendary in Renoir's circle at the end of the century. From what we know about Aline's version of the dish — that a native of Marseilles taught her to make it and that she made it only on the most special occasions — we can guess that its magic derived from its basic ingredients: the freshest local fish (scorpion-fish, John Dory, red mullet) and the best olive oil. In the early years of Renoir's life with Aline, her mother did the cooking. The dishes Madame Charigot prepared were refined: soufflés, blanquette of veal, and caramel custard. Renoir's own tastes ran to food in a more peasant style, as is made clear by his son's account of their visits to the south of France. ⚜

A kitchen table in Paul Cézanne's studio in Aix-en-Provence, 1991

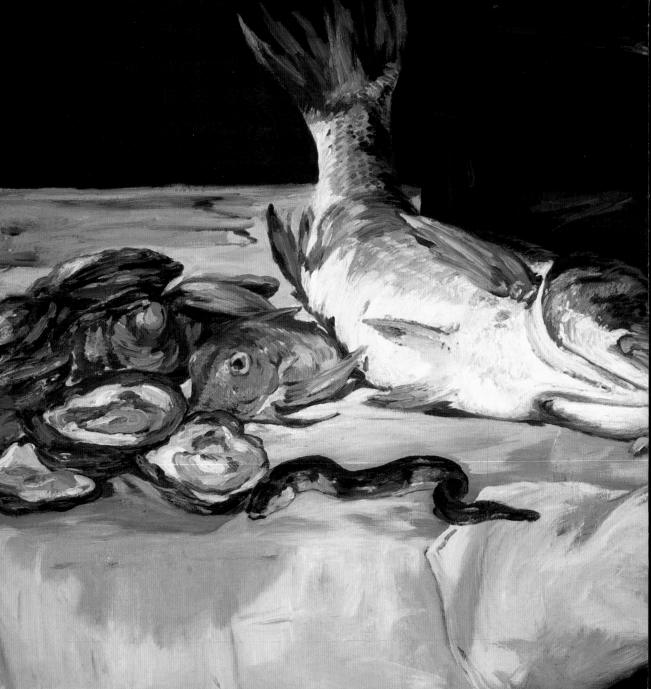

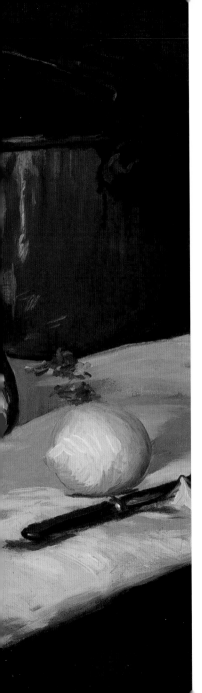

[Charlotte Berthier] told all her friends about the Renoirs' bouillabaisse. "Madame Renoir gives a few vague directions to her husband's model, who keeps an eye on the kitchen between sittings. And what happens? My bouillabaisse is uneatable and hers is marvelous."

— Jean Renoir

Edouard Manet, *Still Life with Fish* (detail), 1864

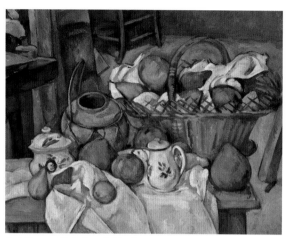

Paul Cézanne, *The Kitchen Table* (detail), 1888–1890

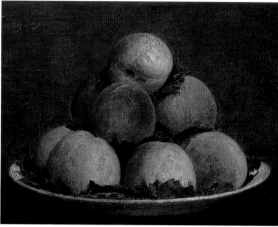

Henri Fantin-Latour, *Peaches* (detail), 1869
RIGHT: Paul Cézanne, *Ginger Pot with Pomegranate and Pears* (detail), 1890–1893

Before an ordinary painter's apple one says: "I could

eat it." Before an apple of Cézanne's, one says: "It's beautiful!"

One would not dare peel it, one would like to copy it.

That is what Cézanne's spirituality is.

— Paul Sérusier

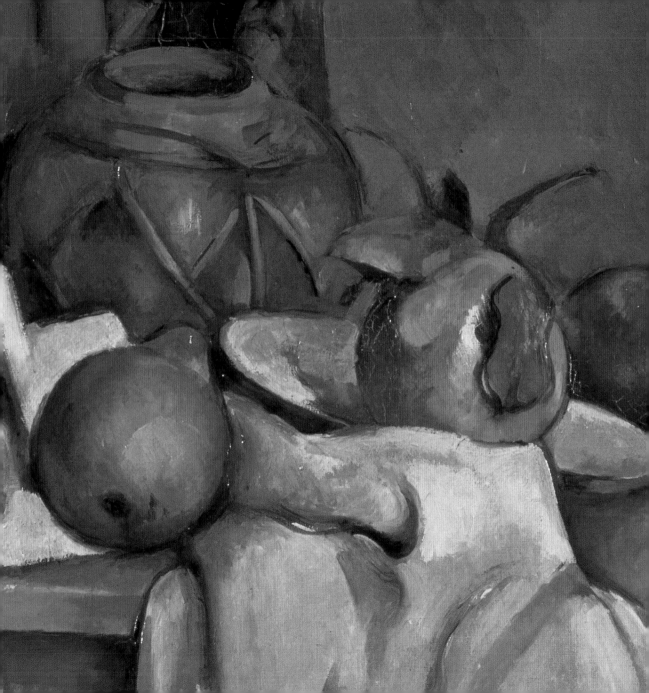

What most enraptured me were the

asparagus, tinged with ultramarine and pink

which shaded off from their heads, finely

stippled in mauve and azure, through a series

of imperceptible gradations to their white

feet — still stained a little by the soil of their

garden-bed — with an iridescence

that was not of this world.

— Marcel Proust

Edouard Manet, *A Bunch of Asparagus* (detail), 1880

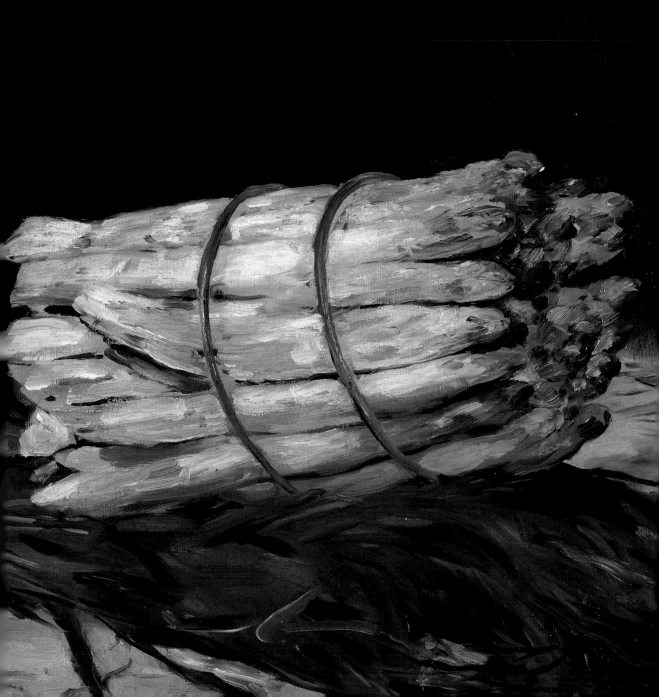

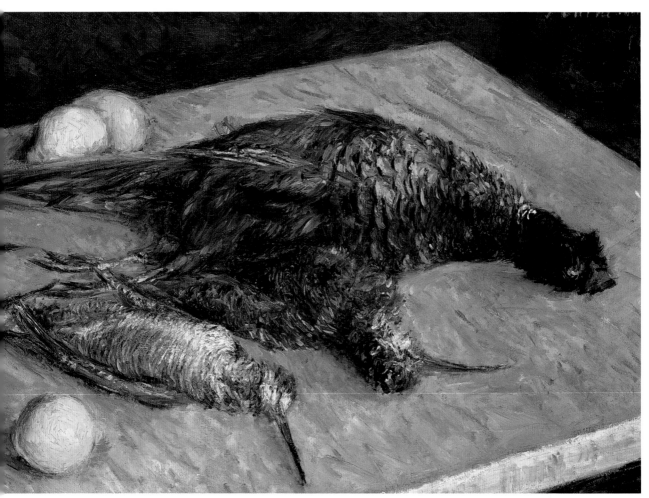

Gustave Caillebotte, *Game Birds and Lemons* (detail), 1883

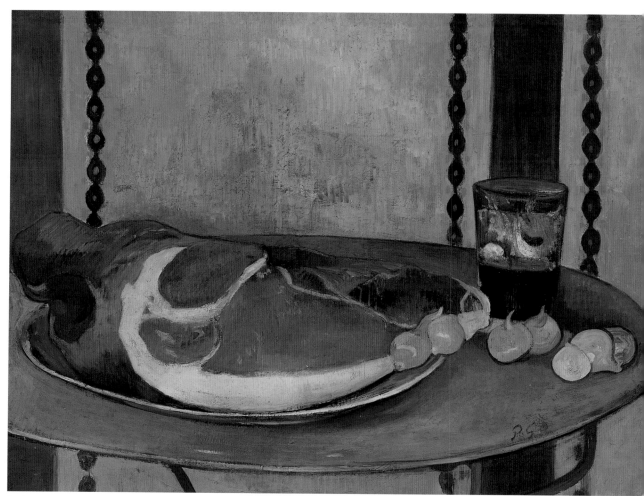

Paul Gauguin, *The Ham* (detail), 1889

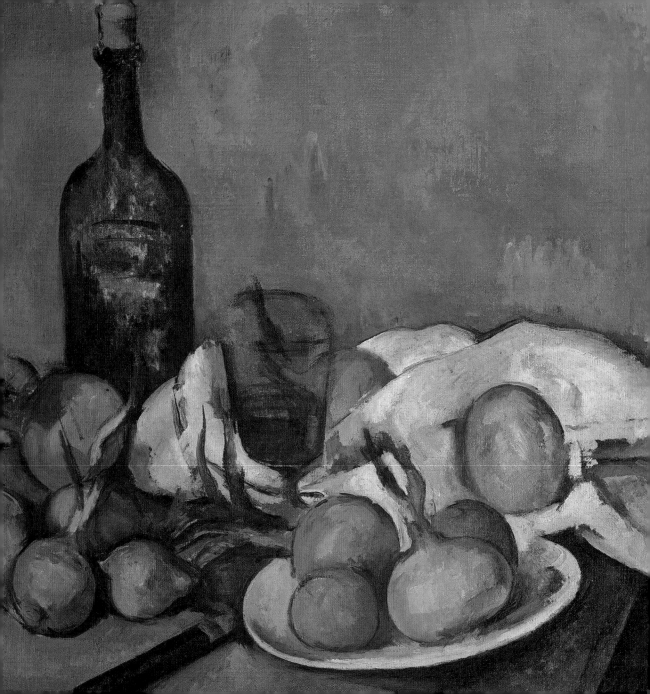

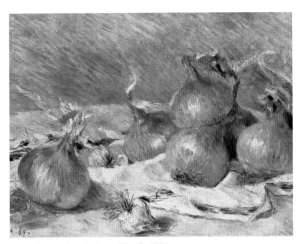

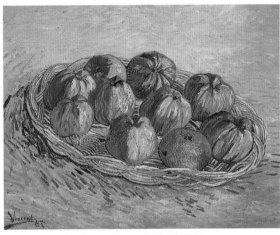

Pierre-Auguste Renoir, *Onions* (detail), 1881
LEFT: Paul Cézanne, *Still Life with Onions* (detail), 1896–1898

Vincent van Gogh, *Still Life: Basket of Apples* (detail), 1887

By the time he got back, he found his wife busy with her preparations

for the midday meal. . . . He would sit down beside her and help her to scrape

the carrots. She felt happy then and started a little song though a bit off

key, as she told me afterwards. Then, he would put down his knife, take out

his pad and pencil, and start sketching her.

— Jean Renoir

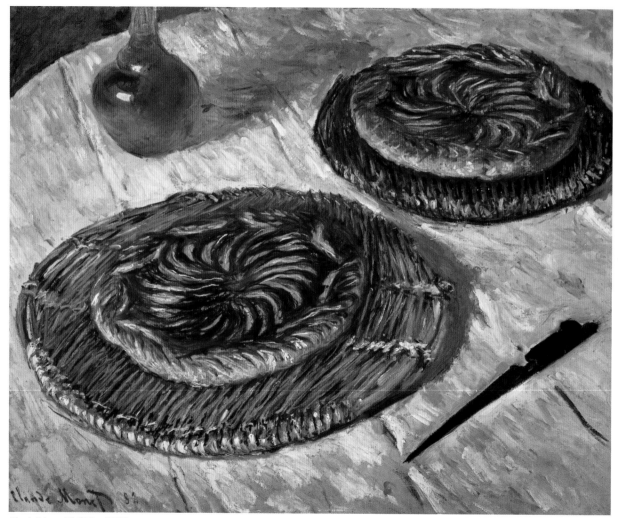

Claude Monet, *The "Galettes,"* 1882

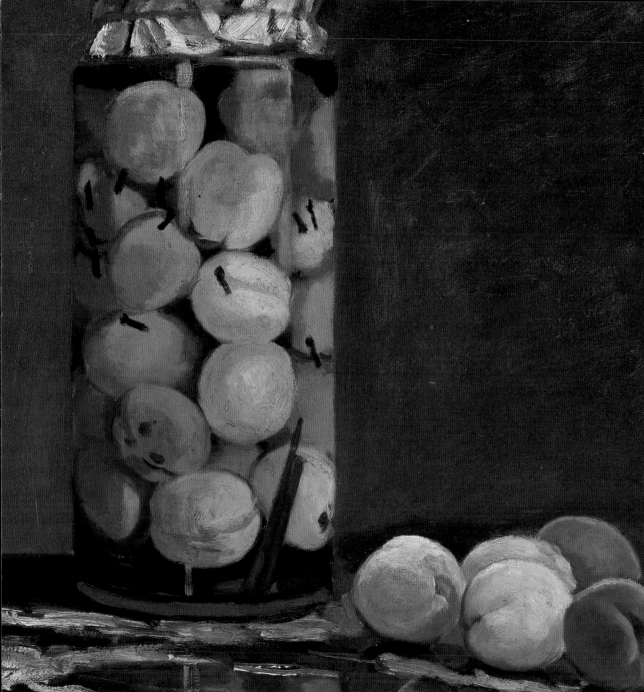

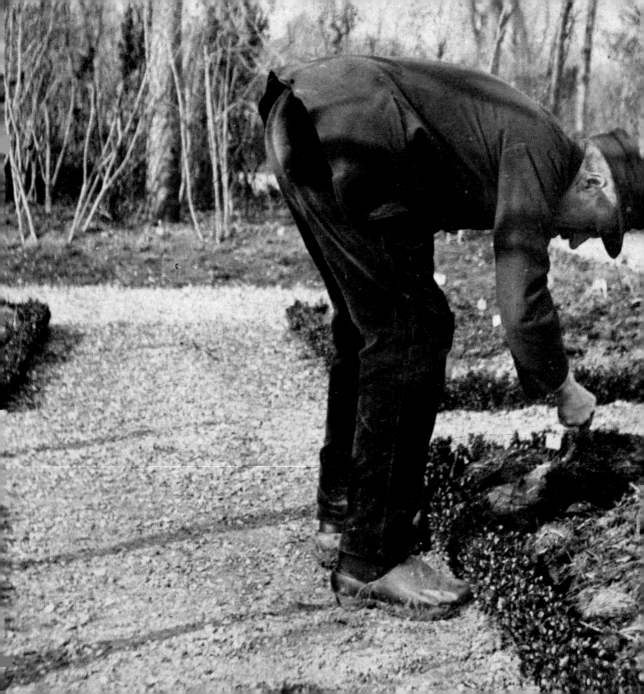

FROM THE GARDEN

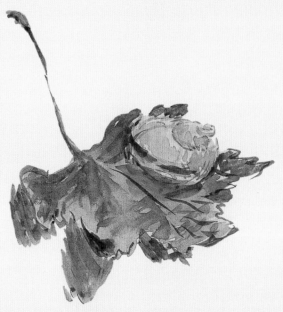

At the heart of Impressionism is the life of the garden. Whether the artists cultivated gardens

or merely cast their discerning eyes over the gardens they visited, the experience shaped the works they produced. Their images of gardens convey a sense of sociable leisure and the enjoyment of time spent out-of-doors. The middle-class garden, as a motif for the Impressionists' paintings, would greatly further their artistic researches into the effects of light.

Domestic gardening gained popularity during this period. Growing flowers, once an aristocratic activity, became a pursuit for wealthy members of the middle class. Manuals and journals aimed at fledgling gardeners began to appear. Fairs and expositions touted discoveries and techniques. Even the development of a practical rubber garden hose happened around this time. With the opening of Japan at mid-century, new varieties of large-flowering chrysanthemums, Japanese irises, and tree peonies began to be cultivated.

Edouard Manet, detail from illustrated letter (snail on leaf), 1880
PRECEDING: A gardener working on the grounds of Gustave Caillebotte's residence at Petit-Gennevilliers, 1892

Many other plants arrived in Europe from far-flung colonies, while hybridization of plant stocks introduced large numbers of new plants to the market. Novelty bred novelty, and the fortunes of particular flowers rose and fell with changing tastes. In the 1860s a taste for flowers with a more free form and relaxed appearance was driven in part by the arrival in 1862 of the Japanese-style large-flowering chrysanthemum. The dahlia, imported from Mexico, was cultivated in Europe from 1789. By 1826 there were sixty varieties of dahlia, and twelve hundred by 1841. The more formal-looking show or fancy dahlias, with their quilled heads, filled the tents at flower shows in the 1830s and 1840s but were displaced in popular favor in the 1870s by the chrysanthemum-style cactus dahlia.

Painters invested in their gardens — even on properties that they were only renting — because gardens offered an alternative to both the sallow light of the studio and the arduous trek to outlying landscape motifs. Those artists who could afford to do so — such as Claude Monet and Gustave Caillebotte — even employed the help of professional gardeners. In the daylight stood varieties of plants and flowers, with paths worked through them, dotted with the simple forms of garden furnishings. The structure was there: against it the painters recorded the constantly shifting movement of light and shadow. Gardens also provided a ready source of material for still-life paintings, when the market for such paintings appeared to be expanding.

Monet's earliest plantings on the grounds of his rented property at Giverny in 1883 were prompted by his desire to have some flower stalks to paint in case bad weather prevented him from working out-of-doors. That the gardens grew further is no surprise — Monet had planted gardens at his homes in Argenteuil and Vétheuil — but the extent of the gardens' growth and the estimate that they are the subject of some five hundred works by Monet indicate that two strong passions had been conjoined. Originally advised by Caillebotte, Monet became a keen garden planner and student of horticulture. By the mid-1890s, the gardens at Giverny kept a staff of six busy. A vegetable garden was consigned to a separate property. Ultimately, Monet added the famed water garden to the grounds.

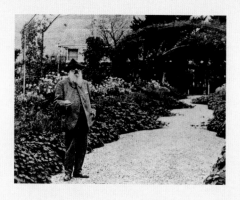

We walked beneath the poplars to see the greenhouse, where there are magnificent chrysanthemums. Then on to the ornamental lake, across which there is a green bridge that looks rather Japanese.

—Julie Manet (on Giverny)

Garden historians laud Monet for the layered color contrast his plans provided and the vertical interest created by trellises and arbors covered in climbing plants such as clematis, morning glory, and wisteria. In the range of middle height, above the beds planted with annuals and perennials, Monet placed a layer of color by planting French lilac, crab apples, or ornamental cherry trees. In their complex variety, Monet's garden vistas were quite unlike the floral still lifes he painted in the late 1870s and early 1880s, where masses of one kind of flower fill the picture's surface.

Caillebotte, who was referred to as "that wise amateur of the garden" by critic Gustave Geoffroy, first developed his expertise at his family's estate at Yerres, southeast of Paris. After the sale of that property in the late 1870s, Caillebotte started a one-acre garden at Petit-Gennevilliers, northwest of Paris. His energies there extended to roses, dahlias, chrysanthemums, greenhouse orchids, and espaliered fruit trees.

In Paris, Renoir had a studio and a residence in Montmartre, both with adjoining gardens. They were basically uncultivated, but Renoir enjoyed the flowers that "volunteered" their presence, either from past plantings or neighboring lots. In the south of France, at Les Collettes near Cagnes-sur-Mer, Renoir also adopted a "hands-off" policy toward his gardens, although his wife, Aline, planted a formal rose garden so that Renoir could further explore through painting his long-standing affinity with that flower. Owing to the fair climate, Renoir had ample supplies as well of anemones, ranunculus, and carnations.

Between 1881 and 1884, Berthe Morisot, her husband, Eugène Manet, and their young daughter, Julie, resided for seasons at a time in Bougival, on the Seine near Paris. Paintings of her

Claude Monet in his garden at Giverny, c. 1925

family in the garden make up much of her work from this time. The gardens appear almost generic to the period (green benches, bobbing white or red flowers), and serve as a basic setting for the figures and the brilliant light that surrounds them.

Edouard Manet, a die-hard Parisian, spent time at his family's gardens in Gennevilliers, opposite Argenteuil, in the 1860s. (The peonies he loved were grown there.) And, in the last years of his life, while undergoing various medical treatments, he passed time in a skimpily planted garden near Versailles, of which he painted a view—although he detested the ugliness of the place.

For van Gogh, the experience of gardens in Arles and Saint-Rémy was part of his search to find a place for himself and his art. Walking along roadsides or through public gardens, he noticed motifs that corresponded to his research into color theory, begun earlier in Paris. Upon turning to still lifes, he mined a similar vein, relying on the juxtaposition of colors to convey emotion. By restricting his compositions to a single kind of flower, he tested the potency of those theories.

Like gardening, the flower business boomed in the nineteenth century. Floriculture became an independent branch of agriculture. Glasshouses, marvels of mid-nineteenth-century engineering, made floriculture possible on a commercial scale. Markets and florists stocked flowers from greenhouses and country gardens. Flowers cut in the south of France arrived by rail within twenty-four hours. After mid-century, a vogue for conservatories or winter gardens led to the creation of eclectic hothouse environments in affluent homes. Flowers or live plants had many customary uses. In advance of houseguests, bouquets of flowers were set out as a visible sign of hospitality. Other occasions demanding floral tribute were birthdays, name days, and anniversaries.

Eugène Manet, Berthe Morisot, and their daughter, Julie, in Bougival, 1880

In producing floral still lifes the Impressionists were responding to the market for such paintings, furthering their love of gardens, and expressing the Parisian style they absorbed from the seamstresses, hat-trimmers, florists, and other retail tradespeople who were part of their society. The addition of an inscription could transform these small works into witty and personal souvenirs. A painting of an object would become a gift in lieu of the object itself, which although well remembered, was not available for giving. Flower arrangements were often one element of a still life attempting to suggest the mood of a domestic interior. The flowers in Morisot's *Dahlias* hover above a table surface on which a lady's fan has been temporarily put aside by its owner, perhaps implying her movement from one conversational group or from one task to another (see page 44). Closed or half-open books placed beside bouquets also appear in still lifes of this period, alluding to the intimate reveries that occur when one is lost in the world of a book (see page 41).

During the last two years of his life Manet produced twenty floral still lifes. Of modest scale and great elegance, these paintings were a respite from his larger works during his debilitating illness. The choice flowers in them arrived as gifts from friends: roses, lilacs, clematis, pinks. The compositions made much of the simple glass vessels half-filled with water or the counter upon which they sat (see page 51). Despite the exigencies of his life, Manet shaped masterpieces of understatement not possible in other genres of painting.

Manet's poignant wit can be seen in his *Bouquet of Violets,* in which the fan held by Morisot while posing for his *The Balcony* in the 1860s is set next to the bunch of violets she wore in Manet's portrait of her. A folded piece of paper nearby reveals the inscription "A Mlle Berthe." The simple objects sum up their many shared moments. By virtue of being present in a painting, they reach parity with Manet's many works that have Morisot, his sister-in-law, as a model. Given to Morisot, the painting reminded her of her friendship with the artist and her role as his model. Morisot was with Manet and his family during his last days, and she was wracked by the suffering she observed. Writing to her sister after Manet's death, her frame of reference was the same as the still life's: "I shall never forget the days of my friendship and intimacy with him, when I sat for him and when the charm of his mind kept me alert during those long hours." ⚜

Claude Monet, *Vase of Flowers,* c. 1881–1882

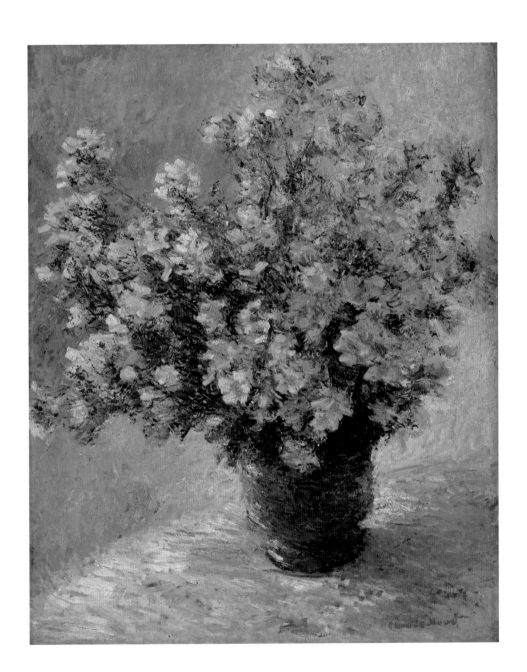

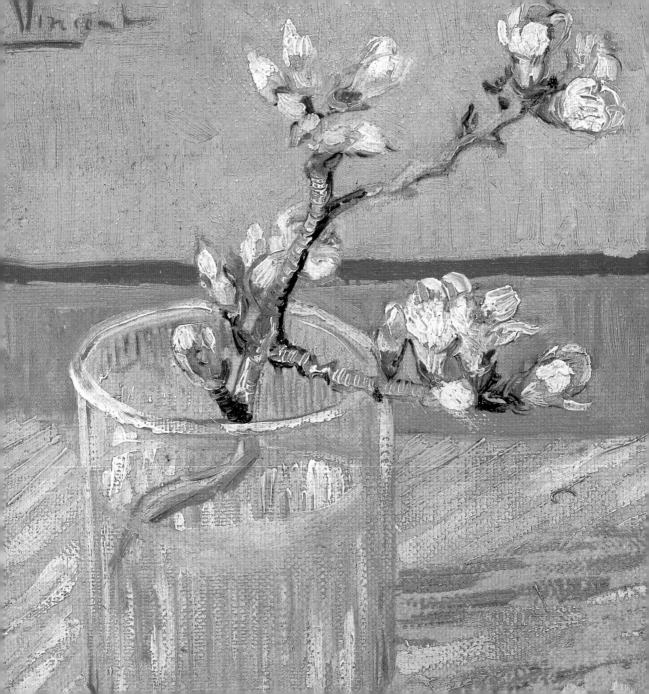

But for one's health, as you say, it

is very necessary to work in the garden

and see the flowers growing.

— Vincent van Gogh

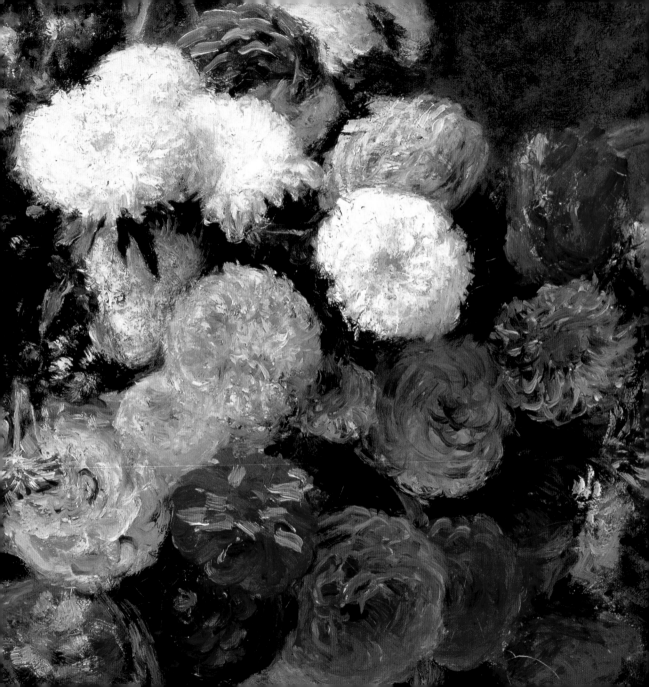

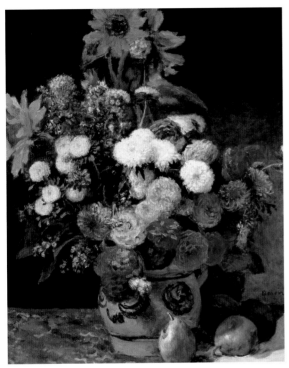

Pierre-Auguste Renoir, *Mixed Flowers in an Earthenware Pot*
(detail above and opposite), c. 1869

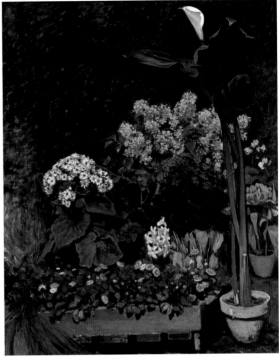

Pierre-Auguste Renoir, *Spring Flowers* (detail), 1864

It relaxes my mind to paint flowers. I do not bring to
it the same tension of spirit as when I am in front of a model.
When I paint flowers, I arrange the tones, I try out
different values boldly, without worrying about wasting a canvas.

— Pierre-Auguste Renoir

They invited me, those chrysanthemums, to put
away all my sorrows and to taste with a greedy rapture
during that "tea-time" hour the all-too-fleeting
pleasures of November, whose intimate and mysterious
splendour they set ablaze all around me.

— Marcel Proust

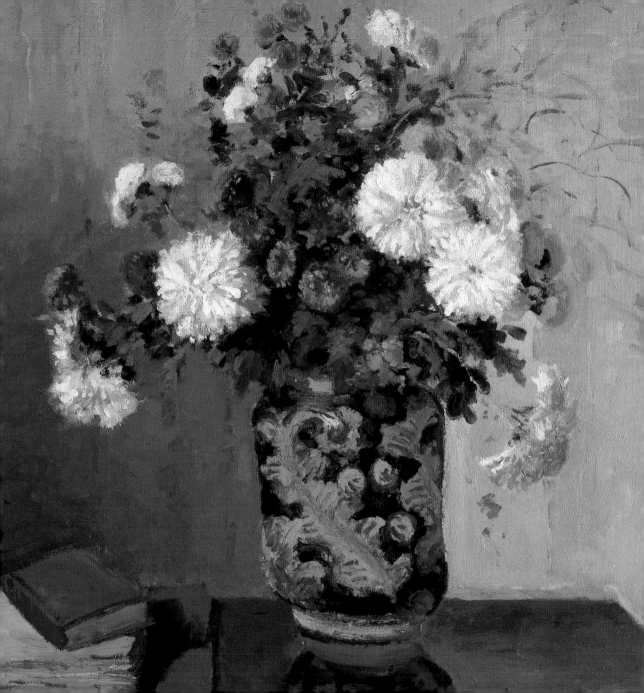

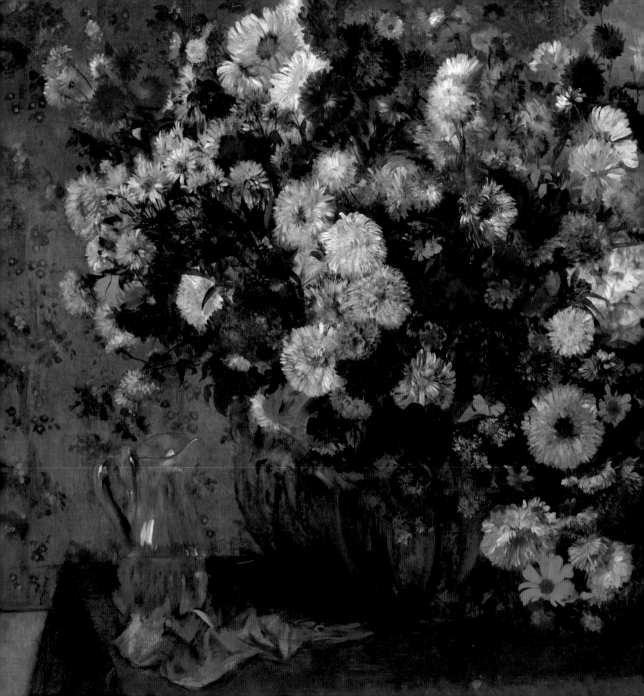

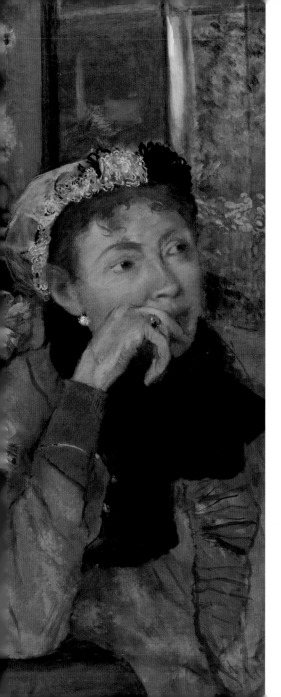

Edgar Degas, *A Woman Seated beside a Vase of Flowers*
(Mme Paul Valpinçon?) (detail), 1865

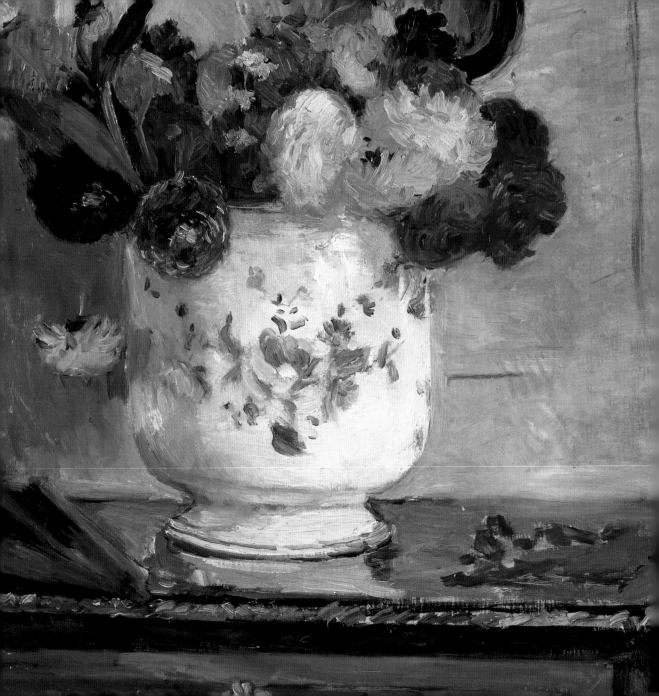

The gloom of the vestibule shot
with rays of pinks and gold and white by
the fragrant petals of these ephemeral
stars, which kindle their cold fires in the murky
atmosphere of winter afternoons.

— Marcel Proust

Berthe Morisot, *Dahlias* (detail), c. 1876

I am working at it every morning from

sunrise on, for the flowers fade so soon, and

the thing is to do the whole in one rush.

— Vincent van Gogh

Vincent van Gogh, *Roses* (detail), 1890
FOLLOWING: Edouard Manet, *Bouquet of Violets* (detail), 1872

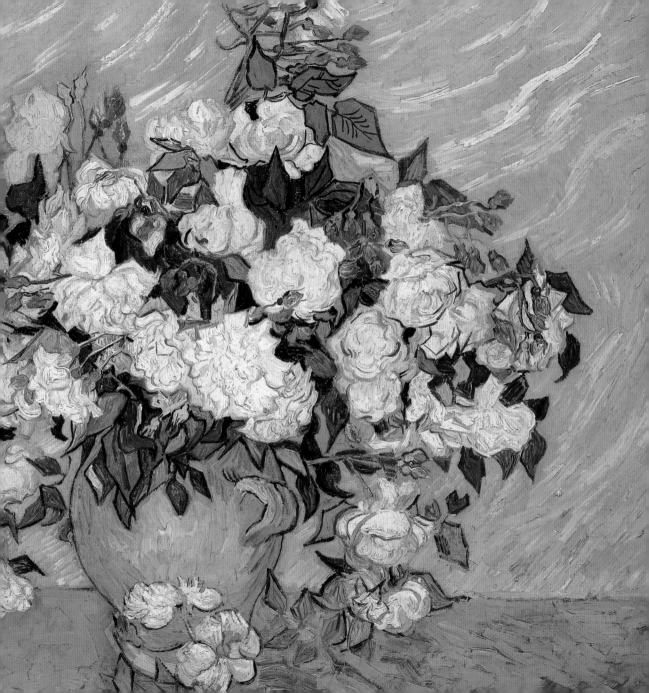

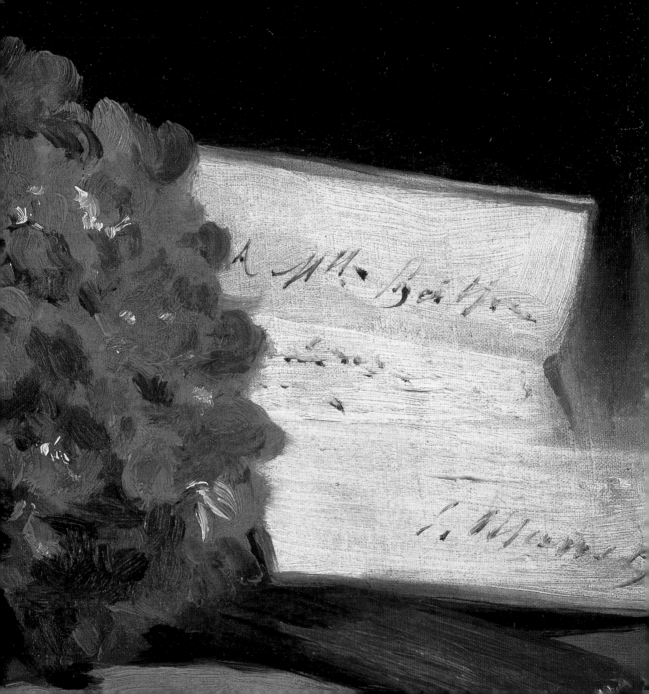

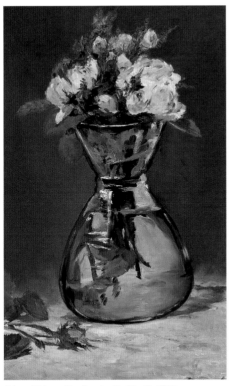

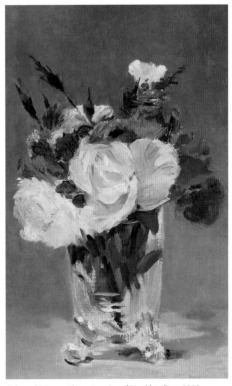

Edouard Manet, *Moss Roses in a Vase* (detail), 1882

LEFT: Henri Fantin-Latour, *The Betrothal Still Life* (detail), 1869

Edouard Manet, *Flowers in a Crystal Vase* (detail), c. 1882

Deep flowers, with lustre and darkness fraught,
From glass that gleams as the chill still seas / Lean and
lend for a heart distraught / Heart's ease.

— Algernon Charles Swinburne

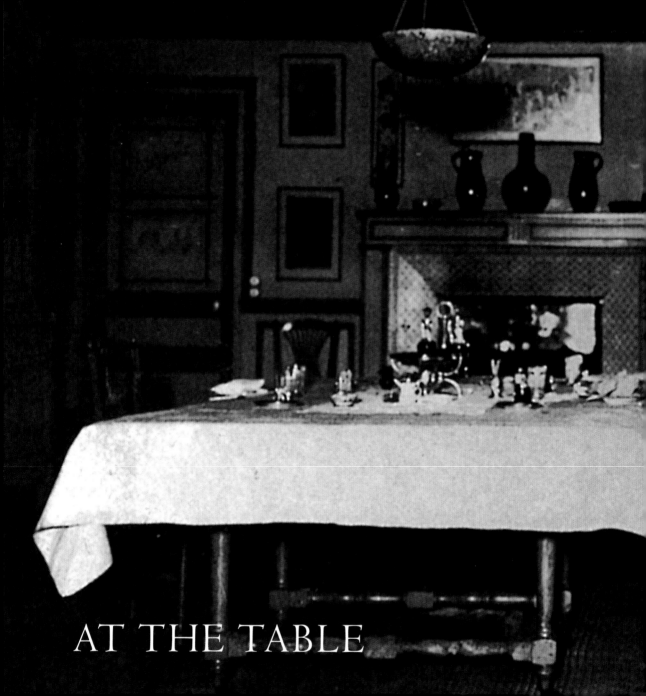

AT THE TABLE

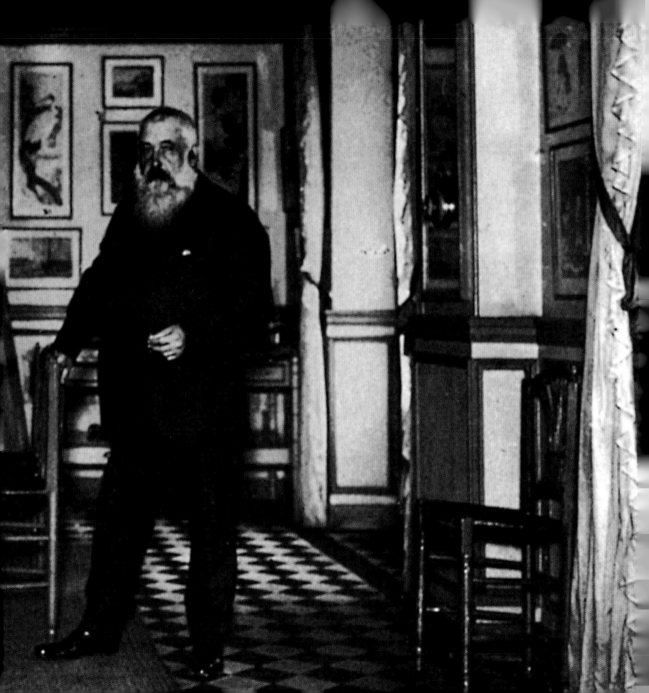

When a French host calls out the typical summons to dinner — "à table"— the guests' spirits rise

in anticipation of the time to be shared with friends and loved ones together around a table. The communal space, food, and the accessories for the meal's enjoyment all hold some promise of hours of pleasure and rejuvenation ahead. Various customary meals — breakfast, luncheon, even picnics — often became the subject of figural works by the Impressionist painters. Through such scenes they frequently asserted their commitment to presenting modern life in all its significance as a subject for painting. But they also turned to the table itself as a subject for still-life painting, and these works, small scale and less demonstrative in tone than the figure paintings, offer another window onto their world.

During the 1860s and 1870s Impressionism and its creators both grew in the sociability of the café, an environment less personal than one's apartment or studio. In the Café Guerbois and the

Edouard Manet, detail from illustrated letter (chestnut), 1880
PRECEDING: Claude Monet in his dining room at Giverny, c. 1898

Café Nouvelle-Athènes, literary and artistic allegiances were formed, important issues were debated, and a new range of subject matter was explored. By the 1880s, the painters recognized that they were encountering one another less frequently at the cafés and opted to schedule regular dinners together, often at the Café Riche on the boulevard des Italiens.

Restaurant dining had recently become more possible for the general public. Before the French Revolution, a wide gulf existed between the cuisine of the commoner and that of the aristocrat. Aristocratic meals were characterized by imagination, wit, and elaborate confection — far removed from the simple quelling of hunger that was the goal of the commoner's meal. After the Revolution, the famed chefs of princes and counts remade themselves, first into proprietors of cafés and beverage stands, and then into restaurateurs, operating establishments for the new middle classes. Beginning in 1865, the chef at the Café Riche, the elder Bignon, who came from a heritage linked to the old aristocracy, propelled the restaurant to the top rank. His menu extended to more than forty pages. A meal lasted six or more courses — not counting hors d'oeuvre, salad, and dessert. Its purpose was to ease the diner, through sequential alteration of ingredients and modes of preparation, into a feeling of well-being. The names of the dishes on the menu were filled with allusions to all sorts of things from famous chefs (Robert, Carême) to moments in history (the battle of Marengo) to famous diners (Prince Demidoff). The Café Riche itself even bequeathed its sauce to history: *sauce à la Riche*, a reduction of fish stock and cream, enriched by lobster butter, brandy, and a pinch of cayenne pepper.

The Impressionists found inspiration among these relatively new public eating places. Caillebotte, wealthy and sophisticated, painted an extravagant *Still Life with Crayfish*, with the crustacean shown not raw but elaborately prepared as *langouste à la parisienne* (served with aspic, vegetables, and truffles, in its shell) accompanied by stacks of plates and nested cutlery (see page 60). Surely this painting alludes to a sideboard in an expensive restaurant. Similarly, his *Still Life: Oysters*, complete with place setting and artfully folded napkin, suggests a table in a restaurant, where well-off Parisians typically consumed their oysters (see page 62).

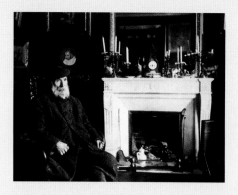

The nineteenth century opened the gustatory realm to the middle classes and invited them to sample the best that Paris could offer. In the bourgeois home, the schedule of meals was modified. The evening meal, called dinner in Paris and supper in the provinces, was served later and later as the century progressed in order to accommodate the working schedule of the bourgeois man. Women received guests of both sexes in the afternoon, serving them tea with sandwiches and cakes (see page 74). A modest domestic version of the several-course meal evolved. At Giverny, Monet's well-off household consumed a three-course luncheon plus salad and at dinner another three courses plus salad and cheese. Yet, by and large, the Impressionists avoided the sense of a whole meal in their paintings, focusing instead on the quiet pauses before or during a repast.

The dining room and its furniture — the suite of table and chairs — was a creation of the nineteenth century. Prior to this, tables served many purposes besides meals, depending on how they were positioned and dressed. The bourgeois household wanted to impress through a specific space and ceremony devoted to entertaining. Dining rooms were important ritual spaces where the gleam of silver and the brilliance of glass, porcelain, and other accoutrements — among them, still-life paintings themselves, with appropriate themes, such as seasonal foodstuffs — helped indicate the fortunate circumstances of their owner. In fact, Manet's *The Salmon*, one of the larger Impressionist still lifes of a table scene, may have been painted as part of a decorative scheme for a patron's dining room (see page 65).

The dining room table was draped with a cloth of linen damask (named for Damascus, a major market for silk yarns and fabrics in the Middle Ages). The cloths were white, and the patterns

Pierre-Auguste Renoir before his fireplace, 1912

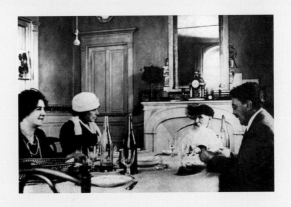

[Monet] liked his asparagus very lightly cooked, and would have a separate dish of more thoroughly cooked asparagus for his guests.
— Jean-Pierre Hoschedé

were woven tone-on-tone into the fabric in either geometric or figural style (see page 64). Such linens, constituting a major part of a bride's trousseau, were expensive, and their proper use identified a household as prosperous. Cleaning and pressing them kept laundresses busy. White damask tablecloths were not used at luncheon on weekdays because guests were rarely present. Instead, the luncheon cloth might be ecru or might have a red or blue border. Similarly, at tea, other colors — patterned gray damask in the home of Proust's Gilberte Swann — were acceptable.

In Impressionist still-life paintings, so much depends on the tablecloth. For the painters, this cloth, unfurled over a surface, brought many pictorial advantages. It bounced light toward the still-life motif. It brought shadows cast by the objects into prominence, making them greater factors in the composition. The rectilinear pattern of folds in the cloth also showed as shadow and created a type of grid that could enhance the sense of recession into space. The lines of folds anchored the bright white surface to a given plane, increasing the sense of tangible, measurable space between still-life objects.

Upon these expertly painted monochromatic surfaces, the painters organized nuts, fruit, and flowers. The sense of activity is limited. It is as if — just a minute ago — the peaches or pears were stacked in a decorative pyramid, and only now has one of them been isolated for eating (see page 68). Pieces of cutlery, usually knives, angled across the table, invite the viewer to enter the space and give a ready sense of proportion, based on the grasp of a person's hand. Especially in peeling fruit, the knife becomes an extension of the hand, gauging the depth of a slice or the pressure on the blade. Nearby faïence or porcelain containers put glazed pigments next to the palette of nature.

Pierre-Auguste Renoir dines with friends at Les Colettes, Cagnes-sur-Mer, France, c. 1900

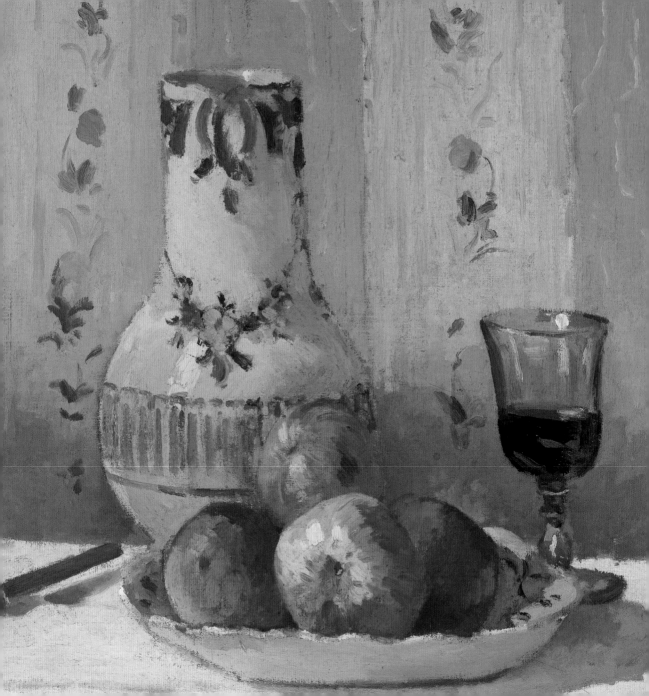

Beneath the dashes of light reflected off their surfaces, floral design motifs — still-life motifs them-selves at one remove — are spaced, as if celebrating the natural world.

Henri Fantin-Latour had much commercial success with his still lifes and paved the way for later Impressionists. Manet, Monet, and Camille Pissarro worked on still life periodically from the 1860s to the 1880s. However, the painter who produced more still lifes than all of them was Paul Cézanne. Cézanne, whose early efforts in the genre were much admired by Manet, later worked with Pissarro, sharing still-life props and settings.

Cézanne was not at all interested in bourgeois notions of restraint and decorum. Mary Cassatt gave an amusing account of his appalling table manners: "He scrapes his soup plate, then lifts it and pours the remaining drops in the spoon; he even takes his chop in his fingers and pulls the meat from the bone. He eats with his knife and accompanies every gesture, every movement of his hand, with that implement, which he grasps firmly when he commences his meal and never puts down until he leaves the table."

By the late 1880s, Cézanne's still lifes began to diverge from their affinity with the works of other Impressionist still-life painters as he began using the still life for intense formal and spatial experimentation. In his paintings from this period, the table still has a nominal presence, as do the crockery, fruit, and table linen, but the fiction of the dining room has vanished completely. The tablecloths are wrenched, twisted and bunched into the spaces between the objects. The fruits are only the most hard and durable. The dishes are a series of angled planes and volumes whirling around axes (see pages 16–17). Depictions of modern life have given way to the phase of modernism where the "how" of painting takes center stage. ❧

Camille Pissarro, *Still Life with Apples and Pitcher* (detail), c. 1872

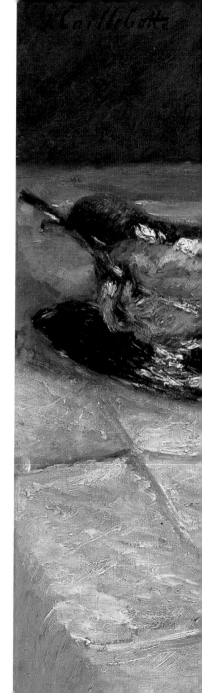

At seven o'clock, dinner was served. . . .
Emma felt, upon entering, enveloped by warm
air, a mix of the perfume of flowers
and of fine linens, of roasting meats and of the
scent of truffles. . . . The red claws of lobsters
were overflowing their plates; large fruits
were piled up on moss in openwork baskets; the
quail were unplucked, aromas wafted up.

— Gustave Flaubert

Gustave Caillebotte, *Still Life with Crayfish* (detail), 1880–1882

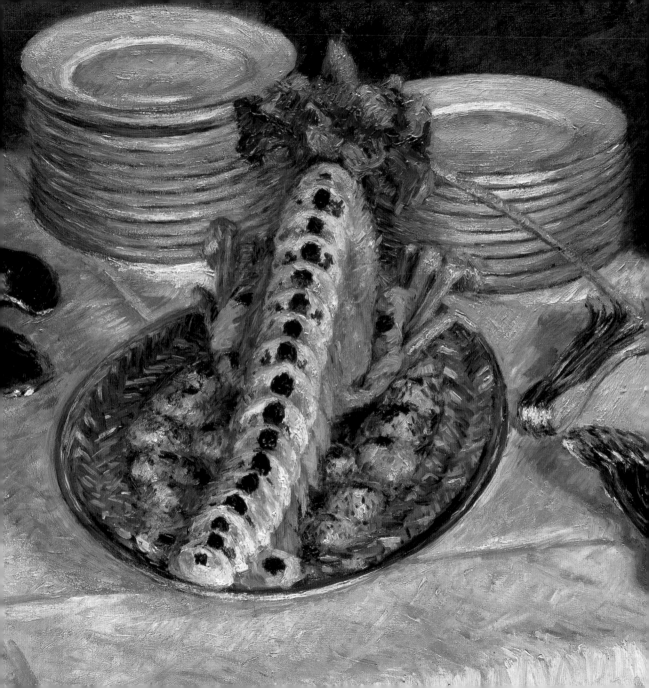

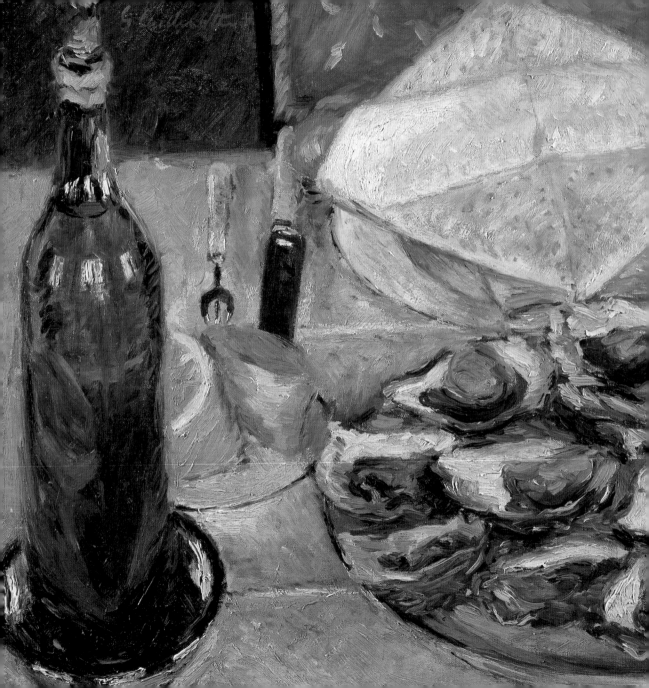

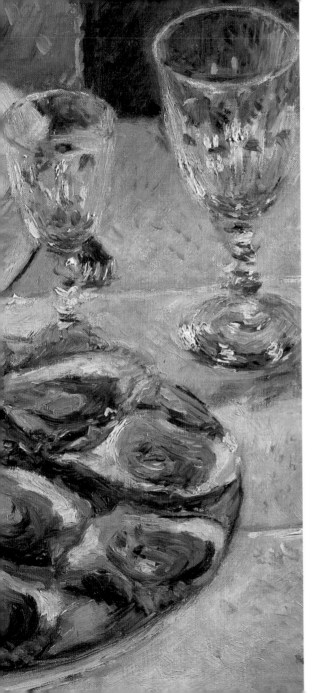

In the hollows of the oyster-shells,
a few drops of lustral water had
remained as in tiny holy water
stoups of stone; I tried to find the
beauty . . . in the most ordinary things,
in the profundities of still life.

— Marcel Proust

Gustave Caillebotte, *Still Life: Oysters*, 1881

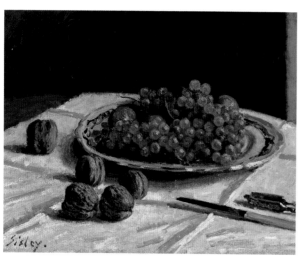

Alfred Sisley, *Grapes and Walnuts on a Table* (detail), 1876

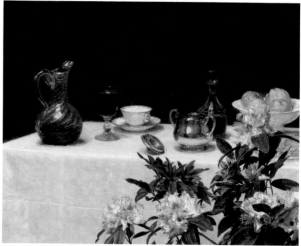

Henri Fantin-Latour, *Still Life: Corner of a Table* (detail), 1873
RIGHT: Edouard Manet, *The Salmon* (detail), c. 1864

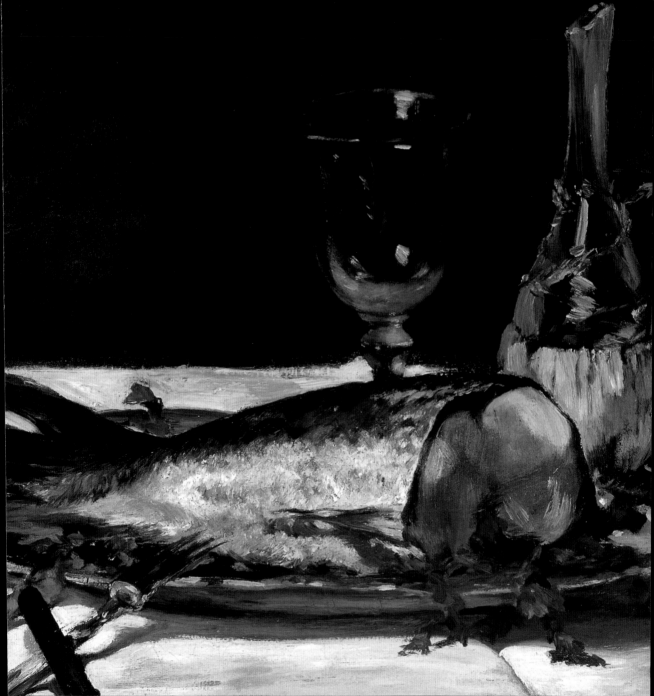

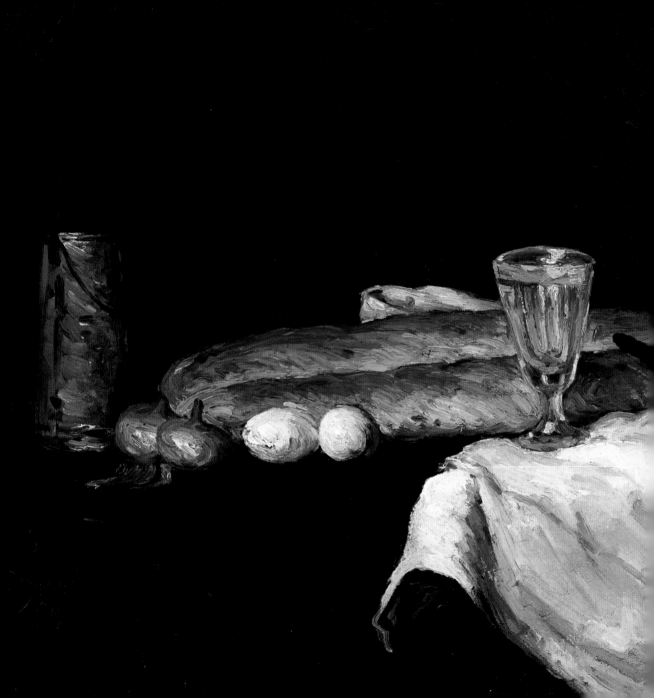

*My father had a fire lit, and
was waiting for us in the dining room.
We quickly toasted a piece of bread,
poured some oil on it while it was still
warm, added a little salt, and
then gave Renoir the pleasure of being
the first to taste the first oil of the
year. "A feast for the gods," he said, while
we, in turn, ate our fragrant bread.*

— Jean Renoir

Paul Cézanne, *Still Life with Bread and Eggs* (detail), 1865

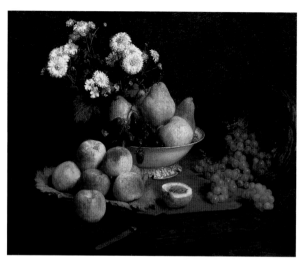

Henri Fantin-Latour, *Flowers and Fruit on a Table*, 1865

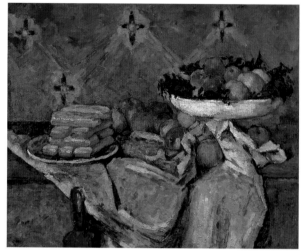

Paul Cézanne, *Compotier and Plate of Biscuits* (detail), c. 1877
RIGHT: Paul Gauguin, *Still Life with Peaches* (detail), c. 1889

Balzac speaks of a table laid, he makes a still life of it, "a
cloth white as a sheet of newly fallen snow on which the table things
stood out symmetrically crowned with small pale yellow rolls."
All my youth I wished to paint that, a cloth of newly fallen snow.

— Paul Cézanne

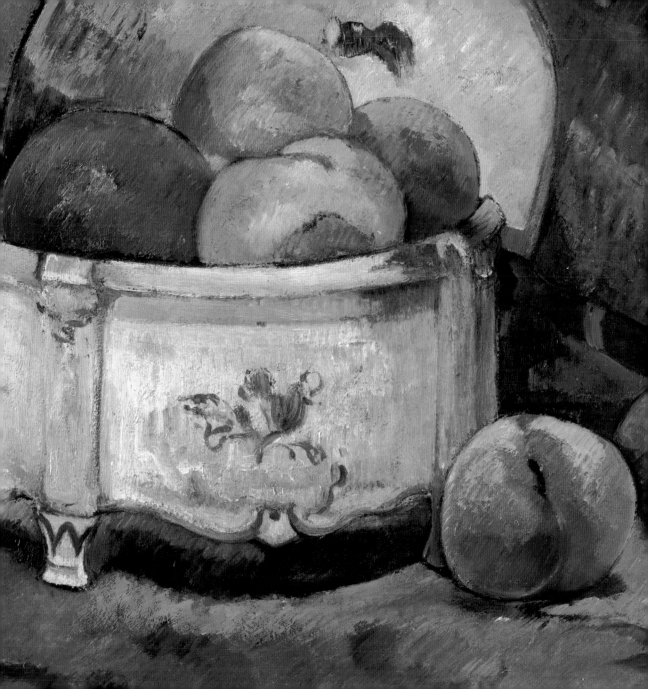

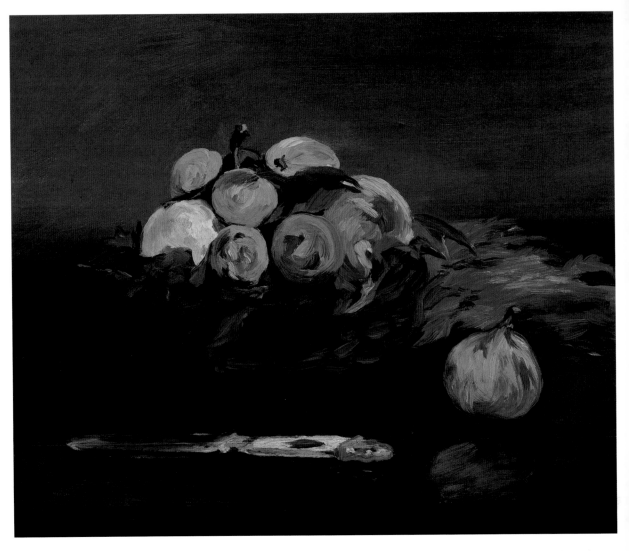

Edouard Manet, *Basket of Fruit*, c. 1864

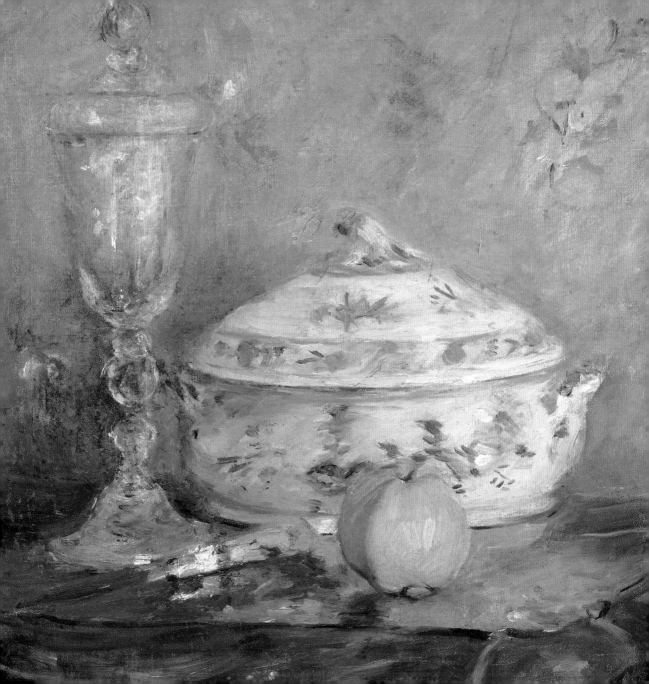

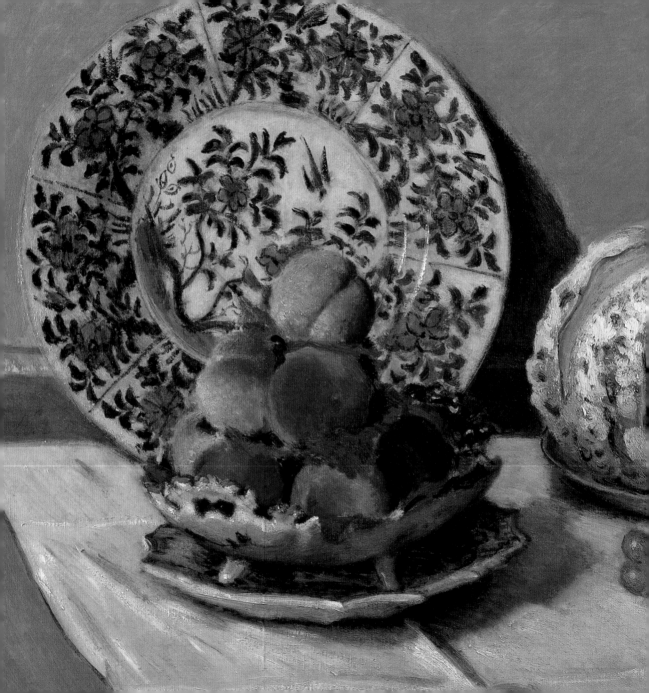

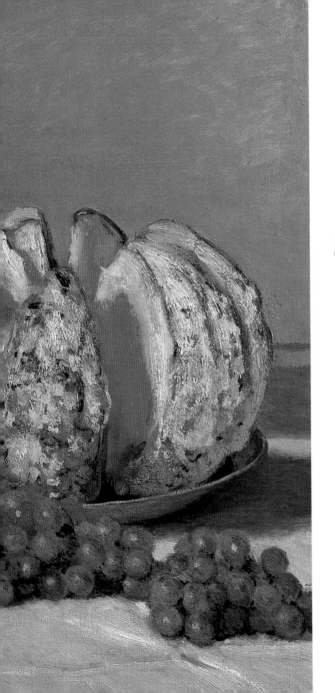

The earth is not round. An orange
is not round. Not one section of it
has the same form or weight as another.
If you divide it into quarters, you
will not find in a single quarter the
same number of pips as in any
of the other three, nor will any of
the pips be exactly alike.
— Pierre-Auguste Renoir

Claude Monet, *Still Life with Melon* (detail), 1872

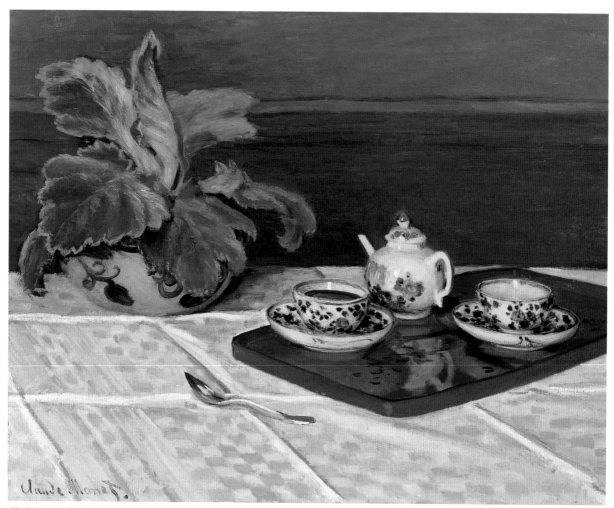

Claude Monet, *The Tea Set*, 1872

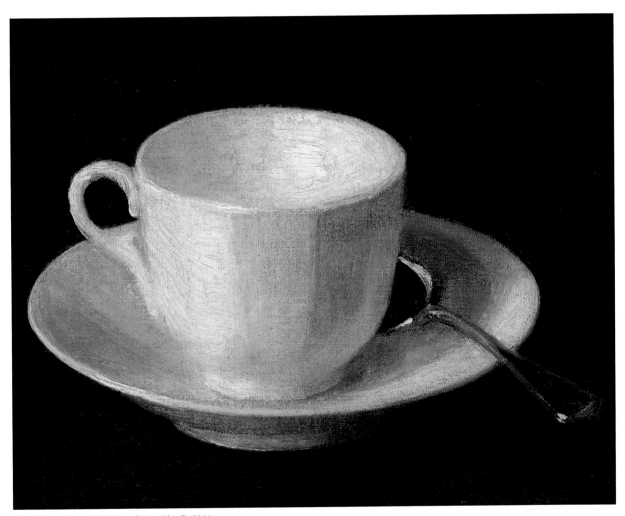

Henri Fantin-Latour, *White Cup and Saucer* (detail), 1864

Sources

References are to page numbers. Unless otherwise noted, translations were done by the editors.

12 Julie Manet, *Growing up with the Impressionists: The Diary of Julie Manet*, trans. and ed. Rosalind de Boland Roberts and Jane Roberts (London: Sotheby's, 1987), 74.

15 Jean Renoir, *Renoir My Father*, trans. Randolph and Dorothy Weaver (Boston and Toronto: Little, Brown and Company, 1962), 265.

16 Paul Sérusier. Quoted in Bernard Dorival, *Cézanne*, trans. H. H. A. Thackthwaite (New York: Continental Book Center, 1948), 142.

18 Marcel Proust, *Swann's Way*, vol. 1 of *Remembrance of Things Past*, trans. C. K. Scott Moncrieff and Terence Kilmartin (New York: Vintage Books, 1982), 131.

23 Jean Renoir, *Renoir My Father*, 260.

30 Julie Manet, *Diary*, 43–45. Quoted in Bernard Denvir, *The Chronicle of Impressionism* (London: Thames & Hudson, 1993), 193.

35 Vincent van Gogh, letter to his mother and Wil, summer 1890 (#650). Quoted in Debra Mancoff, *Van Gogh: Fields and Flowers* (San Francisco: Chronicle Books, 1999), 23. From *The Complete Letters of Vincent van Gogh*, 3 vols. (Boston: New York Graphic Society, 1958).

39 Pierre-Auguste Renoir. Quoted in Georges Rivière, *Renoir et ses amis* (Paris: H. Floury, 1921), 81.

40 Marcel Proust, *Within a Budding Grove*, vol. 1 of *Remembrance of Things Past*, 641.

45 Marcel Proust, *Swann's Way*, 240.

46 Vincent van Gogh, letter to Theo, August 1888 (#526). vol. 3 of *The Complete Letters of Vincent van Gogh*, 3 vols. (Boston: New York Graphic Society, 1958), 19.

51 Algernon Charles Swinburne. Quoted in Elizabeth Hardouin-Fugier and Etienne Grafe, *French Flower Painters of the Nineteenth Century*, ed. Peter Mitchell (London: Philip Wilson Publishers Limited, 1989), 61.

57 Jean-Pierre Hoschedé, *Claude Monet: ce mal connu*, vol. II (Geneva, 1960), 81–82. Quoted in Bernard Denvir, *The Chronicle of Impressionism* (London: Thames & Hudson, 1993), 219.

60 Gustave Flaubert, *Madame Bovary* (Paris: Garnier Frères, 1961), 45.

63 Marcel Proust, *Within a Budding Grove*, 929.

67 Jean Renoir, *Renoir My Father*, 438.

68 Paul Cézanne. Quoted in Bernard Dorival, *Cézanne*, 103.

73 Pierre-Auguste Renoir. Quoted in Jean Renoir, *Renoir My Father*, 241.

Index of Featured Works

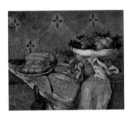

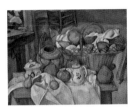
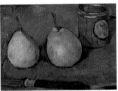
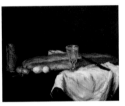
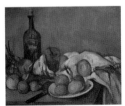
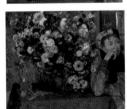

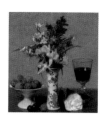

Henri Fantin-Latour (1836–1904)
The Betrothal Still Life, 1869
Oil on canvas, 32 x 29 cm
Musée de Grenoble

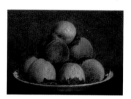

Henri Fantin-Latour (1836–1904)
Flowers and Fruit on a Table, 1865
Oil on canvas, 59.5 x 73 cm
Courtesy, Museum of Fine Arts, Boston

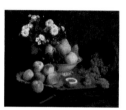

Henri Fantin-Latour (1836–1904)
Peaches, 1869
Oil on canvas, 19.1 x 27.9 cm
Collection of Duncan Vance Phillips
Courtesy of The Phillips Collection,
Washington, D.C.

Henri Fantin-Latour (1836–1904)
Still Life: Corner of a Table, 1873
Oil on canvas, 97 x 125 cm
The Art Institute of Chicago

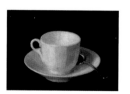

Henri Fantin-Latour (1836–1904)
White Cup and Saucer, 1864
Oil on canvas, 19 x 28 cm
Fitzwilliam Museum, Cambridge, England

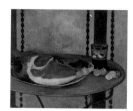

Paul Gauguin (1848–1903)
The Ham, 1889
Oil on canvas, 50.2 x 57.8 cm
The Phillips Collection, Washington, D.C.
Acquired 1951

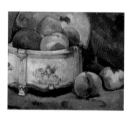

Paul Gauguin (1848–1903)
Still Life with Peaches, c. 1889
Oil on panel, 26 x 31.8 cm
Fogg Art Museum, Harvard University
Art Museums, Cambridge, MA.

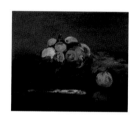

Edouard Manet (1832–1883)
Basket of Fruit, c. 1864
Oil on canvas, 37.7 x 44.4 cm
Courtesy, Museum of Fine Arts, Boston

Edouard Manet (1832–1883)
Branch of White Peonies with Pruning Shears, 1864
Oil on canvas, 30.5 x 45.8 cm
Musée d'Orsay, Paris

Edouard Manet (1832–1883)
Bouquet of Violets, 1872
Oil on canvas, 22 x 27 cm
Private collection, Paris

Edouard Manet (1832–1883)
A Bunch of Asparagus, 1880
Oil on canvas, 44 x 54 cm
Wallraf-Richartz-Museum, Cologne
Rheinisches Bildarchiv, Cologne

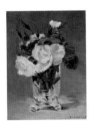

Edouard Manet (1832–1883)
Flowers in a Crystal Vase, c. 1882
Oil on canvas, 32.6 x 24.3 cm
National Gallery of Art, Washington,
D.C.
Ailsa Mellon Bruce Collection
Photo © 2001 Board of Trustees, National
Gallery of Art, Washington, D.C.

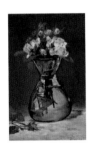

Edouard Manet (1832–1883)
Moss Roses in a Vase, 1882
Oil on canvas, 55.9 x 34.3 cm
Sterling and Francine Clark Art Institute,
Williamstown, MA
1955.566

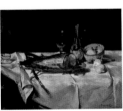

Edouard Manet (1832–1883)
The Salmon, c. 1864
Oil on canvas, 71.1 x 89.9 cm
Shelburne Museum, Shelburne, VT
Photo © Shelburne Museum

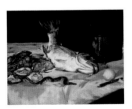

Edouard Manet (1832–1883)
Still Life with Fish, 1864
Oil on canvas, 73.3 x 92 cm
The Art Institute of Chicago
Mr. and Mrs. Lewis L. Coburn Memorial
Collection, 1942.311. Photo courtesy of The
Art Institute of Chicago

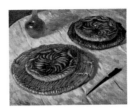

Claude Monet (1840–1926)
The "Galettes," 1882
Oil on canvas, 65 x 81 cm
Private Collection
Giraudon, Bridgeman Art Library, London

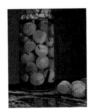

Claude Monet (1840–1926)
Jar of Peaches, 1866
Oil on canvas, 55.5 x 46 cm
Staatliche Kunstsammlungen,
Gemäldegalerie Neue Meister, Dresden
© Staatliche Kunstsammlungen. Gal. Nr. 2525B.
Photo by Jürgen Karpinski, Dresden

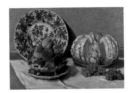

Claude Monet (1840–1926)
Still Life with Melon, 1872
Oil on canvas, 53 x 73 cm
Calouste Gulbenkian Museum, Lisbon

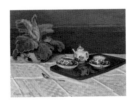

Claude Monet (1840–1926)
The Tea Set, 1872
Oil on canvas, 53 x 72.5 cm
Private collection
Courtesy of Dallas Museum of Art

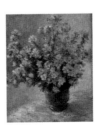

Claude Monet (1840–1926)
Vase of Flowers, c. 1881–1882
Oil on canvas, 99 x 81.3 cm
The Courtauld Institute Gallery, London
Samuel Courtald Collection

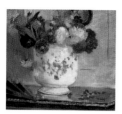

Berthe Morisot (1841–1895)
Dahlias, c. 1876
Oil on canvas, 46.1 x 55.9 cm
Sterling and Francine Clark Art Institute,
Williamstown, MA
1974. 28

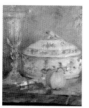

Berthe Morisot (1841–1895)
Tureen with Apple, 1877
Oil on canvas, 56 x 46 cm
Denver Art Museum
Purchased in honor of Mr. & Mrs. Frederic C.
Hamilton with funds from Collectors' Choice
1997, the Anschutz Foundation, Jan & Frederick
Mayer, UMB Bank, U.S. Trust and other donors
by exchange, 1997.218. © Denver Art Museum
2001

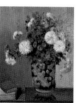

Camille Pissarro (1830–1903)
Chrysanthemums in a Chinese Vase, 1873
Oil on canvas, 61 x 50 cm
Courtesy of the National Gallery of
Ireland, Dublin

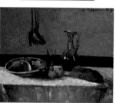

Camille Pissarro (1830–1903)
Still Life, 1867
Oil on canvas, 81 x 99.6 cm
The Toledo Museum of Art
Purchased with funds from the Libbey
Endowment, Gift of Edward Drummond Libbey,
acc. no. 1949.6

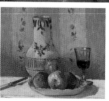

Camille Pissarro (1830–1903)
Still Life with Apples and Pitcher, c. 1872
Oil on canvas, 46.4 x 56.5 cm
The Metropolitan Museum of Art, NY
Mr. and Mrs. Richard J. Bernhard Gift, by
exchange, 1983. (1983.166) Photograph ©
1983 The Metropolitan Museum of Art

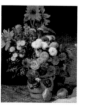

Pierre-Auguste Renoir (1841–1919)
Mixed Flowers in an Earthenware Pot, c. 1869
Oil on paperboard mounted on canvas,
64.9 x 54.2 cm
Courtesy, Museum of Fine Arts, Boston
Bequest of John T. Spaulding. Reproduced with
permission. © 2000 Museum of Fine Arts,
Boston. All rights reserved. 48.592

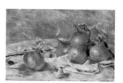

Pierre-Auguste Renoir (1841–1919)
Onions, 1881
Oil on canvas, 39.1 x 60.6 cm
Sterling and Francine Clark Art Institute,
Williamstown, MA
1955.588

Pierre-Auguste Renoir (1841–1919)
Spring Flowers, 1864
Oil on canvas, 129.6 x 96.5 cm
Eigentum der Stiftung zur Förderung
der Hamburgischen Kunstsammlungen,
© Hamburger Kunsthalle.
Photographer: Elke Walford, Hamburg

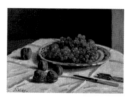

Alfred Sisley (1839–1899)
Grapes and Walnuts on a Table, 1876
Oil on canvas, 38 x 55.4 cm
Courtesy, Museum of Fine Arts, Boston
Bequest of John T. Spaulding. Reproduced with
permission. © 2000 Museum of Fine Arts,
Boston. All rights reserved. 48.601

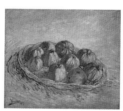

Vincent van Gogh (1853–1890)
Still Life: Basket of Apples, 1887
Oil on canvas, 46.5 x 55.2 cm
The Saint Louis Art Museum.
Gift of Sydney M. Shoenberg Sr.

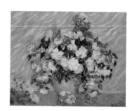

Vincent van Gogh (1853–1890)
Roses, 1890
Oil on canvas, 71 x 90 cm
National Gallery of Art, Washington, D.C.
Gift of Pamela Harriman in memory of
W. Averell Harriman, Photograph © 2001
Board of Trustees, National Gallery of Art,
Washington, D.C. 1991.67.1

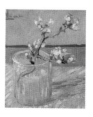

Vincent van Gogh (1853–1890)
Sprig of Flowering Almond in a Glass, 1888
Oil on canvas, 24 x 19 cm
Van Gogh Museum
(Vincent van Gogh Foundation),
Amsterdam

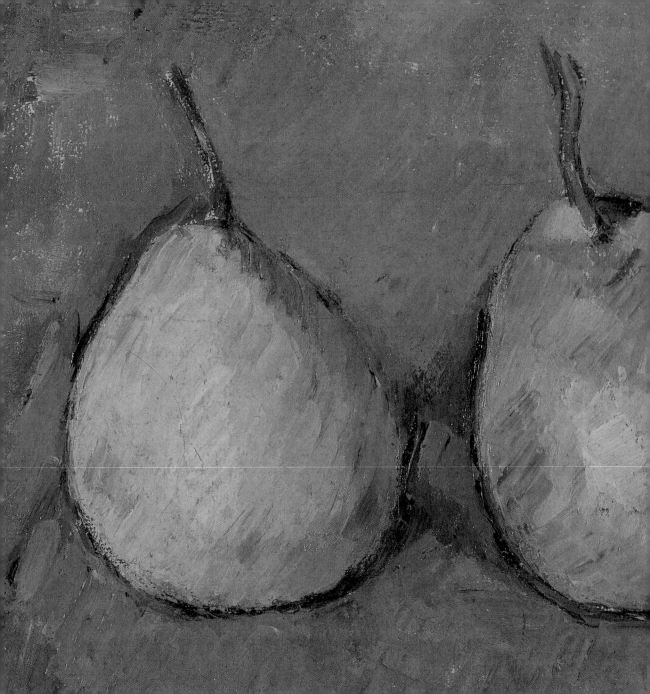